CREATIVITY

JOHNS HOPKINS
UNIVERSITY PRESS

AARHUS UNIVERSITY PRESS

crea

JAN LØHMANN
STEPHENSEN

ELEC
IN

CREATIVITY
© Jan Løhmann Stephensen
and Johns Hopkins University Press 2022
Layout and cover: Camilla Jørgensen, Trefold
Cover photograph: Poul Ib Henriksen
Publishing editor: Søren Mogensen Larsen
Translated from the Danish by Heidi Flegal
Printed by Narayana Press, Denmark
Printed in Denmark 2022

ISBN 978-1-4214-4478-9 (pbk)
ISBN 978-1-4214-4479-6 (ebook)

Library of Congress Control Number: 2022930096

*Special discounts are available for bulk purchases of this
book. For more information, please contact Special Sales at
specialsales@jh.edu.*

Published in the United States by:

Johns Hopkins University Press
2715 North Charles Street
Baltimore, MD 21218-4363
www.press.jhu.edu

Published with the generous support of the
Aarhus University Research Foundation and
the Danish Arts Foundation

Purchase in Denmark: ISBN 978-87-7219-184-3

Aarhus University Press
Finlandsgade 29
8200 Aarhus N
Denmark
www.aarhusuniversitypress.dk

PEER
REVIEWED

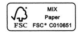

MIX
Paper
FSC FSC® C010651

CONTENTS

FROM SOUTH-WEST THAILAND TO NORTHWEST JUTLAND

SEA GYPSIES IN WONDERLAND

A couple of years ago I was sitting with my family in a longtail boat in the Andaman Sea off Southwest Thailand. As I bent down to pick up a sun hat, which the sea breeze had whisked off the head of one of my sons, I spied a local newspaper crumpled up in the bottom of the boat. Everything except the English-language editorial was in Thai, a language totally foreign to my Danish eyes, so what did I do? I read it.

There we were in the middle of nowhere, not a speck of dry land in sight, bobbing about in an odd-looking, randomly assembled but apparently seaworthy vessel captained by a 'sea gypsy' – as our skipper and his people called themselves – and I found myself reading a piece that urged the local population to transform this part of southern Thailand into a 'creative region'.

For many years authorities and shops in these parts have gone all in to promote tourism, creating a wonderland for holiday makers. Now, instead, influential voices want the region to prepare for a future after tourism, a future based on a catchword you will, by now, have guessed: creativity.

I was not surprised, for we are witnessing a global trend towards creativity. One could almost call it a fad. To use an image from the American sociologist Andrew Ross, it seems as if someone dropped the words 'creative economy' and 'creative industries' to Earth from a great height, spreading them, like balls of mercury exploding into a billion tiny droplets, to reach every corner of the globe. Nowadays, everyone everywhere is relying on creativity as their economic driver.

No wonder people around the Andaman Sea also imagine that energising and harnessing local creativity will be a useful strategy. After all, millions of others want to do the same in *their* local areas: London, Seoul, Montevideo, Adelaide, Odense or the seaside hamlet of Klitmøller, a cold-water surf paradise in northwest Jutland located about as far from the Danish capital as you can get in my small nation without taking a ferry.

They are all convinced – typically after consulting an external branding agency – that they will be able to set themselves apart and use creativity to their advantage, making a 'unique selling point' out of their particular brand of creativity. *Creative Britain. Creative Thailand. Creative Denmark.* Continue the list if you care to. It won't take much creative effort. Therein lies the paradox, obviously: If everyone stands out by being creative, it is hard to see how creativity can give any one place an advantage over other cities, regions or countries, or bring any of us a safer, better future.

MAKE CREATIVITY A HABIT ...

The notion of the economic blessings of creativity originated in the United Kingdom and Australia. It spread like wildfire, sparking a conflagration of very uniform and – if I may be so bold – remarkably unoriginal ideas. One cluster of theories tries to define creativity, while the other tries to work out how we can foster more of it.

The sagging bookshelves in my office testify to the immense importance attributed to creativity these days. Virtually every academic field has written copiously on the topic, especially in the last decade or so. In published works the word itself occurs twice as often as it did in 1970, and the number of books dealing with creativity as associated with work, management, economics and innovation has grown exponentially.

The most notable genre is the 'how-to' handbook in business literature, which teaches us how to make employees and colleagues, teams and companies, even societies more creative. Such books, despite their unabashed focus on the bottom line, also link creativity as a personality trait to our individual projects and identities. As the American choreographer Twyla Tharp put it in *The Creative Habit* from 2003, it is all about our "willingness to make it a habit".

This has woven creativity into the fabric of a whole swathe of management philosophy, posing many questions that seem to be more personal than financial: Who can I be? Who should I be? How can I become the best version

of myself? How do I realise my full potential? Often the answer to these questions is: Be even *more* creative!

We talk about 'creativity' in various and often overlapping terms. It therefore makes sense to talk about 'creativities', as we sometimes do in my field, even though no dictionary I know lists the word in the plural. Part of the special attraction of 'creativity' – as a word and an idea – lies in its richly layered meanings and connotations, which are virtually always seen as positive. This quality is what makes creativity so welcoming as an object of projection, so perfect as a scaffold for our dreams and so utterly seductive.

... AND INNOVATION, TOO!

Over the last two or three decades 'creativity' has increasingly been used alongside another modern buzzword: 'innovation'. In such usage 'creativity' typically denotes the initial phase in developing a new product or business model, a process where people often take a surprisingly linear approach. One step simply follows another. But *creativity*, many would argue, is really about coming up with an idea no one has tried before.

Innovation takes the idea one step further, and the last part of the process, *diffusion*, spreads the product, business model or idea to markets around the world. However, 'diffusion', is such a dry, ugly, technical word that it will probably never enjoy the same popularity as 'innovation' or 'creativity' – despite the fact that diffusion is the step

everyone is most interested in: getting the creative, innovative idea to catch on worldwide.

When discussing innovation we usually emphasise that the result of the creative process must be unique, original or genuinely new – and, not least, relevant. In this context, 'new' is the key word: 'new ideas', 'new products', 'new ways of thinking or working' and 'new ways of doing business'.

This fixation with 'the new' is probably a vestige of a much older conception of some special link between creativity and art. Even so, the tough reality today is that the creative economy is closely linked to what lawyers call 'intellectual property rights': patents, copyrights, trademarks and the like. The pivotal point here is that society determines ownership of an idea based on who came up with it first.

DO SOMETHING – ANYTHING!

The modern link between creativity and innovation usually has an added aspect of utility value, economy and labour. This aspect is quite new, however, and just a few decades ago creativity was perceived very differently.

In historical terms, creativity has been most closely linked to art, a sphere in which financial thinking is widely abhorred. The creative force of the artist must be bound by no other agenda than the exigencies of art itself – at least so say many artists, critics, museum directors and art gallery owners. That is why the world has, instead, applauded the ideas of 'the genius', 'artistic inspiration' and the need

to express oneself, not to mention the perception that creativity somehow, mysteriously, is bestowed upon the likes of Wolfgang Amadeus Mozart or Vincent van Gogh, flowing from within, from without or even from above.

We find traces of this perception in a description of the creative process often attributed to the American conceptual artist Jasper Johns. Of the many attempts to define or capture the essence of 'creativity', this is my personal favourite: It's simple, you just take something and do something to it, and then do something else to it. Keep doing this, and pretty soon you've got something. I interpret Johns' obvious manoeuvre – tiptoeing around an actual definition – in two different ways. Johns could mean that creativity is a mysterious process he cannot or will not try to describe precisely: We do something at some point, and we cannot predict the outcome. This echoes the Romantic perception from the 1800s of creativity as a wondrous, almost magical quality of the genius at work. Discussing creativity may be meaningless, even detrimental, so perhaps he is intimating that we should not speak too much about it, lest we talk it to death.

Alternatively, Johns could mean that creativity is something we all display, all the time. We do something to something for a while, then eventually end up with something we can justifiably call 'creative'. So much for highbrow mystique. And if we interpret the quote in this way – which is what I recommend – then creativity can be very mundane indeed, becoming an ordinary part of our daily lives.

A NEW TAKE ON AN OLD CONCEPT

In a moment I will take you through a brief historical tour of creativity, from antiquity up to our day. First, however, let me explain why you may not get the sort of tour you are expecting. You see, I am obliged to point out that Plato, Aristotle and countless other philosophers down through the ages were *not* in the habit of praising their contemporaries for being creative thinkers.

For one thing, the very word 'creative' is too new for them to have used it at all. The first time 'creativity' appeared as a noun in English to denote a particular character trait was quite late, when it was used in 1875 to describe that most memorable of bards, William Shakespeare. In German and Danish the word appeared later still, in 1956 and 1964, respectively.

This late appearance is partly explained by our having used other words to refer to certain aspects of the phenomenon we refer to today as 'creativity'. 'Genius', 'ingenuity', 'imagination', 'inventiveness', 'originality' and 'inspiration' are strong candidates for the top alternatives.

Even so, it is puzzling that we have not always had one word for 'creativity' as a personality trait. If it really is a fundamental quality in human beings, as many now claim, then why did no one coin a word for it much earlier? Perhaps creativity was only discovered in the late 1800s, so only then did we need a word to describe it?

Or perhaps for us, as children of the modern age, the idea of creativity is associated with certain mindsets and behaviours that we find useful and desirable today? If so,

the reason an older word is lacking might be that in former times people preferred other personality traits, so that our ancestors felt little need to talk about being creative.

I subscribe to the latter explanation. We typically apply the word 'creativity' to thoughts, objects and behaviours that we appreciate and would like to promote – with one notable exception, of course: creative accounting.

I suggest that we not ask what creativity *is*, but instead try to understand what creativity *means to us*. The meaning we attribute to 'creativity', at a given time or in a given context, says much about how we perceive the world and our place in it. Significantly, the meaning it holds for us as individuals reflects our interests, personal and communal, as well as the controversies to which these interests give rise.

I firmly believe this is the most appropriate way to study creativity. It is also the smartest way, as it teaches us more than other approaches do about how we understand the world and see our place in it as human beings.

THE HISTORY OF CREATIVITIES

MAKING SOMETHING FROM NOTHING

Humans have always wondered how things come into existence, and who or what is behind it. Even without the word 'creativity' to describe the process and the phenomenon, we have always imagined creation and creators.

As my choice of words reveals, this conception of creativity resonates with the biblical account in the Book of Genesis, where God created Earth out of nothing (Gen. 1:2–3): "And the earth was without form, and void; and darkness was upon the face of the deep. And the Spirit of God moved upon the face of the waters. And God said: 'Let there be light': and there was light."

Using divine creative force, an omnipotent being produces a complete world out of nothing. There is one gesture, a single moment and a clear idea about what is to be given physical form and existence. There is one Creator, and only one. There is one Creation, and only one. What is more, the originator has a special right to the world 'He' created. For it was 'He' who originally conceived the idea to produce something that did not previously exist.

We refer to this understanding of creativity as *creatio ex nihilo* – creating something from nothing. It was the church father St Augustine of Hippo who came up with this phrase in the early fifth century to describe the divine act of Creation.

The Western world mainly understood creation in this way until the late twentieth century – even though, from the 1700s or 1800s onwards, artists were an important exception to the divine monopoly. They were seen as endowed with the ability to create art from nothing. As the German Romantic poet Johann Wolfgang von Goethe once put it, speaking of opera, every good work of art "creates a little world of its own, in which everything follows certain laws, seeks to be judged according to its own laws, seeks to be experienced according to its own character".

A BEING CREATED CANNOT CREATE

For Augustine and many theologians and philosophers of later centuries, however, Divine Creation was the only kind of creation that counted. This is clear from another of his famous statements, the dictum *"creatura non potest creare"*, which I shall take the liberty of loosely translating as: the created being or *crea*-ture – meaning our kind, the human being – has no capacity to create.

I intentionally refer to Augustine's statement as a 'dictum', an authoritative observation, because it serves a dual purpose. He not only established our limited capabilities compared to the Creator's but also built in an order, telling humans not to think that they, as humans,

have any ability to create. God has a monopoly on creating, he said, and humankind's role was to find its place in His Creation.

We find this view of the world and of humanity in other central Old Testament stories in which humankind is chastised for not knowing their place, or for being too creative. First there is the Fall, where Adam and Eve, having ignored the Lord's command not to eat from the Tree of Knowledge, are banished from the Garden of Eden. Later there is the Tower of Babel, a grand project to build a human edifice high enough to reach Heaven. God, dismayed with this idea since it would raise humans up to his level, punishes them by making them speak different languages, confounding the tower and any similar attempts in the future.

After Augustine launched the idea of God's monopoly on creating, it remained a cornerstone in the unshakable taboo against humans as creators that lasted nearly 2,000 years. This taboo was so strong that people were not even supposed to speak of themselves this way, as they would be challenging God's special position – hence the absence of any need for a word to denote human creativity. In this sense, Augustine's thinking does illustrate how our definitions of creativity are interwoven with cultural and social power structures that otherwise seem unrelated to creativity.

A CREATION IS NO PIECE OF CAKE

In 1831, Goethe wrote to his friend Johann Peter

Eckermann, expressing his annoyance at how especially the French were saying that "Mozart has *composed* Don Juan!" This does not seem the least bit strange today, as we refer to Wolfgang Amadeus Mozart as 'a composer'. What upset Goethe, however, was the specific ideas reflected in the verb itself, as if Mozart's opera were "a piece of cake or a biscuit, which had been stirred together out of eggs, flour and sugar!"

Goethe held, instead, that *Don Juan* was "a spiritual creation, in which the details, as well as the whole, are pervaded by one spirit, and by the breath of one life". Mozart did not simply experience random ideas springing to mind, which he gradually pieced together over time. He had brought to fruition a spiritual idea that had come to him in a flash, as a momentaneous but fully formed idea for which he had served as a medium and a shaper. As Goethe put it, Mozart had been "altogether in the power of the daemonic spirit of his genius, and acted according to his orders".

We find a similar description of the creative process in a letter from the well-known Danish composer Carl Nielsen, who in 1915 wrote to his wife, the sculptor Anne Marie Carl-Nielsen:

> "Occasionally I have the feeling of not being myself at all, but merely a sort of open conduit through which there flows a stream of music that mild and mighty forces are moving in a certain divine oscillation".

Goethe and Nielsen both play on an inherited religious metaphor, 'inspiration', which we often use when describing the mysteries of creativity. The Latin origin of this word is *inspirare*, 'to breathe into', as in the Bible's account of God breathing life into Adam when he created humankind.

THE LOST TRADITION

Meanwhile, Goethe also used the religious metaphor to rule out other descriptions of creative processes as false Creation narratives. What he specifically could not accept was that some people inferred that Mozart, while working with his opera, gradually tested various segments of melodies, then assembled them as he found best. No, Goethe writes: The creator of Don Juan "did not make experiments, and patch together, and follow his own caprice".

What Goethe did was distance himself from any fundamentally different understanding of how things come into being. However, more than 500 years before Augustine, Epicurus and other ancient Greek thinkers viewed the world and people very differently. The Greeks adhered to what the British historian of ideas John Hope Mason calls "the lost tradition" because it had been marginalised since Augustine's day. It did not fit Christianity's myth of Creation or its worldview.

Lately the lost tradition has made a strong comeback, notably in the late twentieth century, when a more inclusive

conception of creativity enjoyed a renaissance, not least in the spheres of pop music and digital culture.

In much electronic music, musicians do exactly what appalled Goethe: They patch together and remix recorded sound bites sampled from other people's songs, with or without permission. They find a beat here, a riff there, a line or a phrase, or perhaps just a harmony, then rework it all into a new composition. This art of patching together and remixing already existing material is the essence of the tradition once lost, but found again, which Mason calls *creatio ex materia*.

Champions of the remix genre tend to enthuse over its innovative value, possibly because it involves new technologies, most conspicuously the sampler, which is essentially a digital tape recorder that is 'played' from a keyboard or another digital interface. But this concept is already well known from various low-tech formats such as visual art, where the cut-and-paste techniques known as collage and montage were already recognised in the early twentieth century.

In this light the most sober interpretation, in line with the American electronic composer, artist and writer DJ Spooky, is that the new technologies re-actualise forms of creativity from the lost tradition. In his words, remixing is just "a new way of doing something that's been with us for a long time: creating with found objects" – a cake baked from the ingredients at hand, as the cooks regularly stick their fingers into the batter and add sugar or salt to taste.

JUNKYARDS AND SPARE PARTS

The 2010 documentary *The Promise*, featuring the American rock musician Bruce Springsteen, tells the story of how, in the mid-1970s, he and the E Street Band created the album *Darkness on the Edge of Town*. He likens his own creative process to working at a junkyard, rummaging around and taking a spare engine part from a broken-down jalopy to fix your own car and get it back on the road.

To a rock-loving art and creativity scholar like me listening to the album, this process is not perceptible. In the final mix, *Darkness on the Edge of Town* is a well-rounded, cohesive whole. It stands out as a series of flawless compositions – almost all of which, in signature Springsteen style, tell stories about cars and highways.

To the uninitiated, I can best describe the road to these compositions as an extended experimental garage session with musical spare parts. The workshop shelves are stocked with chorus lines, bridges, verses, riffs and chord progressions, all assembled around fragments of lyrics, stories often hinted at or half told, characters and archetypes, cultural references and hard-hitting, catchy refrains. All these elements and more already existed as tentative sketches for other songs, or they turned up in the studio, only to be combined, broken down and welded together across an original framework of loose ideas. These became new structures that dissolved and sometimes reappeared, almost organically, in new but familiar contexts on later Springsteen albums.

In terms of 'creation', the songs on the album did

not roll straight off the assembly line, like brand new Chevrolets or pristine pink Cadillacs. We cannot hear the hours of clanging and hammering at the junkyard and in the garage, but the sleek chassis and the purring engine are only perfect thanks to the jumble of spare parts embedded in them. In that sense, Springsteen's skills are not just those of the hard-working mechanics he romanticises in many of his songs. His craftmanship is also akin to that of the used-car salesmen he so often portrays as villains.

So perhaps Goethe was wrong? Perhaps Mozart's creative process, like Springsteen's, was the result of long hours of experimental work with the material, borne by constant reassessments and sudden flashes of insight. Or, as Jasper Johns might have put it: Mozart also did something to something, and suddenly he had something. An opera. *Don Juan*. At any rate, that, we learn, is how Springsteen's creative process works.

I would contend that this process is not particular to music but applies to all art forms. Although creative epiphanies – "It just came to me out of the blue!" – are extremely rare, they make excellent stories. That is probably why music producers and songwriters like to tell each other that 'a good hit is written in less than 15 minutes'. Although I have dabbled in music, I am not a professional songwriter myself, so who am I to say it never happens?

According to Paul McCartney, as one of the Beatles he was able to write 'Yesterday' in a minute, having woken up one December morning in 1963 with the song in his

head. I consider this a rare exception that confirms the rule. A friend of mine, a Danish author, drily remarked a few years ago, after repeatedly sending his first novel back and forth to his editor, that he had stopped harbouring any romantic illusions of 'the sublime moment of creation'. As an academic writer, I know the feeling.

The Canadian singer-songwriter Leonard Cohen probably did not feel like his famous ballad 'Hallelujah' came to him in a flash in 1984, although the title hints at a revelation of sorts. It supposedly took him several years to write, a process that included paring no fewer than eighty prospective verses down to the four in his studio recording.

This is exactly the sort of creative process Mason describes as being at the core of the 'lost' tradition of what creativity is and how it unfolds. Rather than conceive of the created entity as finished the moment the idea is conceived, the created material is in constant flux in a process that is ever-changing, dynamic, unending. That is why, quite often, rather than balance and harmony the process brings disorder, tension and even conflicts, which sometimes – though not always – become a central feature in what is expressed.

There is an aesthetic choice in how clearly the artist wishes to show the underlying creative process. Revisiting remix, artists like DJ Spooky often make a point of exhibiting the places where they patched things together. Listening to their pieces, one can often hear the crackles and scratches that mark their splicing of different audio sources, even intentionally produced glitches.

Springsteen belongs to a very different tradition where the welded seams are discreetly hidden – until you see the documentary that reveals the spare parts under the exterior.

An important element of the lost tradition is the idea that creative products can have many creators, spread over space and time but all contributing in different ways. The process can be collaborative or done as separate tasks, and contributors may work independently or, in fact, not even be aware of each other's existence.

AN ETERNALLY MUTATING BROTHERLY TEXT

The Danish experimental yet surprisingly popular writer Per Højholt once described literature as "a brotherly text, an endlessly mutating space". According to Højholt, all the literature in the world is one great text, connected by countless links across time and space. Texts, books, novels, poems, essays and academic papers all speak with, about, in and through one another.

If we follow this thought, books also speak with and through films, which speak with and through images, which speak with them through music, and so on and so forth. The world of science and scholarship also works like this. As a scholar and academic writer, I build on the insights, knowledge and written works of others. I find inspiration in, and I am influenced by, many different fields: art, science, technology, economics, politics and more.

While writing this book, that is precisely what was happening. Sometimes I may not even have been consciously aware of it – of whose thoughts I was building

on; of whose words I was unknowingly elaborating on and analysing.

Sometimes I think an idea is my own. Consciously or not, I interpret, twist and turn the insights of others. Sometimes, unavoidably, I misunderstand them. So perhaps I am completely wrong, and Højholt meant something else entirely? Perhaps I am embroidering a thread of my own into his tapestry? If so, it would conveniently highlight the point I just made.

That is why I, too, must consider the possibility that I may be misunderstood. You may read these lines differently from how I intended them. My original focus in Danish may have shifted in translation. You may pass on my thoughts with a different emphasis from the original. In short, the creativity I hope to unfold in this book will always intertwine with other people's creative contributions, even though the only name on the cover is mine. And one of those creative contributors, dear reader, is you.

THE ART OF LETTING GO

So why do we say that someone 'created' something? Why do we linguistically frame it like that?

The Scottish anthropologist Tim Ingold once noted that, at best, it is a legalistic fiction to imagine that we can ever 'finish' or 'complete' a product, and that the creative process has an 'end point'. On the contrary, Ingold says that those who stubbornly cling to this perception are mainly lawyers who specialise in copyrights, patents and other

intellectual property rights. They do this because it serves their clients' interest, and their own. But they also do it because that is how we have learned to perceive creativity: as a phenomenon with a clear starting point and end point, from idea to product, and with a sender easily identified as its creator, the person who has moral and legal ownership and authority over their creation.

Perhaps we ought to say, instead, that a work of art has been 'let go'. The intention is not that the artist should disown the work, leave it behind or even give up on it, but letting it go might avert the misperception that the end product fulfils a specific, preset goal – as if the creator dressed an idea in material form and declared it final and complete.

Quite simply, "finishing is never finished", as the American writer, designer and inventor Stewart Brand once put it. With this in mind, we may as well resign ourselves to the fact that at some point we just have to let go. *Factum est.* 'Tis done. Full stop.

CREATING TECHNO-LOGIES

"THINK DIFFERENT."

Creativity is no longer the preserve of brilliant thinkers and artists. The shifts in recent decades enable us all to pursue everyday creativity in entirely new ways, many of which employ digital technologies – smartphones, tablets, computers and a whole online world of options that can generate and share knowledge and products. At least that is an argument we often hear.

We could also look at these shifts from the opposite angle. Perhaps digital technologies look and work as they do for a reason? After all, they were designed, created, to promote 'inter-creativity' – creativity shared among people – as Tim Berners-Lee, a founding father of the World Wide Web, retrospectively phrased it in the early 2000s.

Perhaps co-creativity is simply one of the basic values engineered into these technologies? It is certainly not the only embedded value, but a surprising number of the players contributing bits and pieces to the world's digital infrastructure over the past four to five decades have had human creativity high on their agenda.

That is why creative options are built into so many of our digital "technologies of co-operation", as the

American tech theorist Howard Rheingold once called them. And when we acquire them, the dream of collective and individual creativeness is part of the package we buy. I would even venture the claim that their huge popularity – and steep pricing – is largely justified by their ability to let people live out their own creative aspirations. With digital technologies we can buy access to, and consume, our own creativity.

One example is the dream that the tech titan Apple used to brand their now famous commercial – "Think different." – from 1997, which kick-started the company's stellar success. The ad presents Apple's core values, paying tribute to "the crazy ones, the misfits, the rebels, the troublemakers, the round pegs in the square holes, the ones who see things differently", spoken as black-and-white images of Albert Einstein, Bob Dylan, Muhammad Ali, Salvador Dalí, Alfred Hitchcock and other luminaries float across the screen. They represent the kind of people who "change things. They push the human race forward." These poster boys of creativity (and a couple of poster girls) are also legendary personalities who – according to key co-founder Steve Jobs, speaking at the campaign launch – would all have been Macintosh users.

FROM FAUST TO BREADCATS

When I scan my Facebook or Twitter newsfeed or check out trends on video-sharing platforms like Instagram and YouTube, I see everyday creativity blossoming everywhere. New digital technologies have hugely influenced our

creativity and, more importantly, our understanding of what being creative is. We share, make and remix the things we create more often and more effortlessly than ever before.

Truth be told, this shared universe is rather pointlessly cluttered with pictures of cats accompanied by silly captions full of intentional spelling errors: 'lolcats', which ostensibly have viewers 'laughing out loud'. A subspecies of the lolcat is the 'breadcat', easily recognisable by the fact it sports a slice of bread around its face. Lolcats and breadcats are visual, 'private' jokes among contemporary digital natives, and whatever non-natives may think, they represent an Internet folk art genre no one could have predicted two decades ago.

As quality goes, few would disagree that feline Internet photos are a far cry from literary works like Goethe's novel *Faust* and Shakespeare's play *Macbeth*, or musical works like Mozart's *Don Juan*. We almost seem to be talking about different types of creativities – yes, in the plural.

But quality aside, the important point is that not only are we *creating*, we are also *sharing* our creativity. That is what makes it meaningful to say that people in the modern world behave and act differently: We participate. We create. This is nothing short of a cultural revolution.

Many of us have actually become co-creators of culture, and historically large numbers of people are now involved in processes that can reasonably be called creative, either at work or at home. We could also say that the division of work between 'creatives' and 'non-creatives' has changed.

'Authorship' – defined as the person or persons who create something, whatever their medium – has mushroomed. We have succeeded in democratising creativity, turning it into a pursuit that allows ordinary people like us to be more than onlookers. We are participants. Creativity permeates daily life through our activities, interests and diversions. We praise it, cultivate it and aspire to it, and we see it as relevant for everyone, ourselves included.

IN DIALOGUE WITH THE MATERIAL

The next cultural revolution is already under way, bringing with it an even wider idea of authorship that is no longer reserved for humans. In my research field we now talk about 'post-human creativity', indicating something that goes beyond *Homo sapiens* and breaks our monopoly on doing creative things. Today's powerful computers, smart phones and software are actively co-creating.

Humans have always used tools in their creative processes, obviously. Mozart used a piano, manuscript paper, notebooks and a quill. Painters like Picasso, Dalí and van Gogh used paints and canvases, often after an initial paper-and-pencil phase. Shakespeare, Goethe and Hemingway all used paper and writing utensils of some sort.

These materials probably played a more active role in the authors' creativity than we ever cared to acknowledge. Humankind's creative processes have always been in dialogue with the materials we have used, often with a trial-

and-error approach that tests, rejects and transforms ideas by using drafts or models in tangible, material form.

That is precisely why art lovers and scholars are so intrigued by the pencil sketches and studies that preceded masterpieces such as Leonardo da Vinci's *The Last Supper* or Pablo Picasso's *Guernica*. They shed light on how the artist worked with the material – the dialogues between artist, material and tools, if you will. A traditional oil painting, on the other hand, conceals its own fabrication process, as the thick layers of paint eventually cover all the preliminary work, giving the illusion that it came into being suddenly, created from nothing in one sublime moment of inspiration.

Concerts, too, are built around dialogues with material elements. The musicians have a creative interchange with things which, strictly speaking, have nothing to do with the music itself: human organisers and assistants, fellow musicians and the audience. But what we often fail to appreciate is that various non-human factors also play a key role: the instruments, of course, and the acoustic properties of the concert venue.

PSALM-CYCLES AND ODDS AND ENDS

In my younger days I was part of a band that had some small success on the local scene, performing songs we had written ourselves. We spent a lot of time together jamming, practising and composing. Often we would work on a loose idea or a rough sketch someone had brought

along, or we would latch on to something one of us came up with during a session: a riff, a rhythm or a catchy line.

Typically we would start recording very early in the process, letting the eight-track tape recorder run as we played. As I intimated, this was some years ago. Before our next session we would pass a rough mix around, listening to it at home so we could decide whether to use it or toss it. Some went into our 'Got potential?' odds and ends box. Many a tape withered and died there – and may they rest in peace – but most had decent bits that were eventually spliced together with other odds and ends, following the same logic as Springsteen's junkyard and spare parts imagery. Sadly, any comparison with Springsteen and the E Street Band stops there.

At other times we took a different approach. We would even swap instruments, although with one firm rule: Do *not* let Jan play drums. Beyond this, and despite my added inability to make real music on a keyboard, I acquired an old pedal organ – jokingly referred to in bicycle-loving Denmark as 'a psalm-cycle'.

We reasoned that mastering a musical instrument is a skill that can unleash creative potential but can also lead to bad habits and uncreative complacency. Give me a guitar and my fingers wander, almost of their own accord, across familiar ground. Without thinking, I end up playing a theme that sounds a lot like my last song. Sometimes that's fine. It's what gives musicians their style. But sometimes it's just plain boring. In a creative process the instrument or tool also plays a role, for better and for worse. That is why

deliberate excursions into unfamiliar territory – tripping ourselves up on purpose – can be a good thing.

CHASTITY VOWS AND STUMBLING BLOCKS

In the mid-1990s several Danish film directors – Lars von Trier, Thomas Vinterberg and, later, Søren Kragh-Jacobsen and Kristian Levring – launched the idea of 'Dogme film', based on an approach not wholly unlike the experimentation my own band used in writing songs. With films like *The Idiots*, *Mifune's Last Song*, *The Celebration* and *Italian for Beginners*, the 'Dogme Brethren' and their new rules for filmmaking revolutionised the Danish film industry and started a wave of commercial and creative success that also gained a certain following in the international film community.

The movement's central pillar was 'the Dogme 95 Manifesto', a set of ten self-imposed imperatives the dogmatic directors called their 'Vow of Chastity', which, by constraining their work processes, set them free. The aim was to circumvent the usual standards for feature-film storytelling and production, but more importantly they wanted to move beyond the comfort zone they had built up over the years.

Their own virtuosity and technical brilliance was smothering their creativity. To revitalise it they had to find new ways to employ – and in some cases even abstain from using – audio-video recording and editing equipment, film sets, props and costumes, all of which had come to overshadow the creative process and push the acting and

plots into the background. Goodbye habits and routines; hello stumbling blocks.

Lars von Trier systematically presents this thinking in *The Five Obstructions* from 2003, directing his mentor – the Danish independent film-maker and writer Jørgen Leth – to do five remakes of his own short film *The Perfect Human* from 1967. Leth must use techniques and formats he does not master and even some he despises, such as animation. When Leth ends up producing some successful remakes, von Trier gets quite miffed – an obvious dramaturgical ploy, since it proves the point of his setting up the obstacles in the first place.

THE CAMERA AS CO-CREATOR

This further demonstrates that the importance of our utensils, tools, instruments and materials is not new. These elements have always influenced creative processes and their outcomes. But new technologies are upping the game, so much so that it may be wrong to refer to them as mere 'tools' in the conventional sense. They are more like co-creators in our processes, a sort of creative assistant if you will, or even a colleague.

The most interesting tech element is the software that influences and defines virtually all creative production today, for professional photographers and for an amateur like me, cheerfully snapping away on my holiday in Thailand.

In recent decades the way we take pictures and the channels by which we share them have radically changed,

as we rely almost exclusively on the cameras built into our mobiles and their integrated platforms.

The *look* of photos has changed as well. One notable innovation is an entirely new genre: the selfie. The example best known to Danes is doubtless a selfie from 2013 taken by the country's then prime minister, Helle Thorning-Schmidt, alongside US and UK leaders Barack Obama and David Cameron at Nelson Mandela's memorial service. More than the wow-factor of their PM rubbing shoulders with great leaders of the free world, what made Danes – and others – smile was the universal nature of the act and its SoMe infotainment value. Had the image been from a family reunion, her caption might have read: "Chillin' with B and Dave."

Snapping an image with our ever-ready smartphones also triggers a very active software-based editing process, much of which we can control. There are filters and digitally simulated lens and film types, Polaroid and sepia, antique finish, distorted lighting and Kodachrome colours. There is cropping, contrasting and colour adjusting, and a host of other creative image-editing apps we can activate with a click on our camera, or download or access through the platforms we use.

Meanwhile, beneath the surface, the closed 'black box' of our camera is running a range of automated processes we cannot access. One of these corrects the proportions of our motif, which unavoidably becomes distorted through a lens as simple as that of a mobile. These processes, invisible to the user, cannot be actively selected or deselected, and

even if we know they exist, they are extremely difficult to identify.

THE CAMERA MAKES THE PHOTOGRAPHER

In actual fact, all the actions I have ever performed with my mobile camera, and the creative preferences these actions reflect, decide how I will collaborate with the software – here and now, and in the future. My camera is in constant dialogue with my digital photo history. More mind-boggling still is the fact that as soon as I click 'accept update' for a smartphone operating system or an app, all the actions everyone else has performed with *their* cameras will also affect *my* devices and options.

Suddenly I find the updated photo software offering me new options, while my trusty old preferred options have become less accessible, moving further down a scroll menu or disappearing altogether. Manufacturers base these changes on large-scale analyses of what users do with their phones, and of the pictures we share.

In short, the sum of our choices decides which options are offered or available the next time we zoom in on a motif and try to work creatively with an image. It also decides what goes on inside our software's black box without ever giving us a clue.

All these invisible processes profoundly influence the look and feel of the final photo – the product that will ultimately survive to document my visual talent and photographic creativity to myself and to the world. We may create photographs using our cameras or create a new

image culture using sharing and social network platforms like Flickr, Instagram, Snapchat, YouTube and Facebook, but there is more to it. Because the camera interacts so closely with our creativity, it also makes us, creates us, as photographers.

Once again borrowing from Per Højholt, the photo too is an eternally mutating 'brotherly text'. We are all co-authors: humans, devices and software, entangled in one great Gordian knot. Sound and music are no different. Digital technologies have given us new instruments, new artistic and everyday creative genres and entirely new creative processes and workflows, enabled by our collaboration with software. In architecture and film, people also increasingly view the computer as a 'colleague' with its own creative agendas and preferences.

That is why we must prepare to give up the idea of creativity as something particularly human, even though, or perhaps precisely because, we find it hard to see or read creativity otherwise and therefore lack the language to describe it.

Even so, we still talk about creativity in terms that focus on the human factor. We do this because our vested interests are many and varied, as are the values that lie in and behind our creative endeavours. They relate to identity and other soft issues, but also to much more tangible financial issues.

MADMEN – AND MAD WOMEN

THE STORY OF A MOMENT'S MADNESS

Around Christmas 1888 the Dutch painter Vincent van Gogh reportedly cut off his own ear during a brush with insanity. The episode remains hotly disputed among art historians. Had he gone mad from the Mistral constantly blowing across Provence? Was he an alcoholic? Had he argued with his French friend and colleague Paul Gauguin? Or was it something else altogether?

Some say the fundamental premise of the story – that van Gogh wielded the knife himself – is false. He may have been sliced by Gauguin, or perhaps he simply had a fencing accident. Was van Gogh untruthful about the origins of his injury, wishing to protect Gaugin?

However the wound came about, van Gogh painted his *Self-Portrait with Bandaged Ear*, which, besides the bandage, renders the artist's haunted expression. The image is regarded today as the embodiment of a martyred artist's soul, but the painting did not create this mythology on its own.

We have long seen madness, or the struggle to avoid it, as the indispensable creative force in great artists with troubled minds, who, being driven, can create the

extraordinary. An old adage says there is a fine line between madness and genius, and as the German philosopher Friedrich Nietzsche put it a few years before van Gogh's misadventure: "One must […] have chaos in oneself to be able to give birth to a dancing star" – a claim the reputed madness of his own final years would seem to support.

BRILLIANCE ON THE BORDERLINE

Many of our ideas about creativity come from stories like van Gogh's. Such figures typically stand out from the crowd as unique, or they are isolated or marginalised socially and financially. Often they are physically isolated as well, sequestered in a particular space – the laboratory, the workshop, the studio, the draughty attic room. This stages the artist or scientist as someone on the fringes of normal society.

Like the story of van Gogh's ear, many stories about famous eccentrics are more myth or anecdote than fact. However, in recent decades creativity has become a huge research field, or rather, several fields. The topic is no longer abstruse or difficult to approach or discuss, as the Jasper Johns quote suggested, tongue in cheek. Instead, we now ask a variety of new and much more pragmatic questions: What is creativity? How does it work? How can we get more of it?

Back in the early 1900s two Austrians, both of them medical doctors *and* psychologists, were already exploring the seat of creativity in the human mind, especially in relation to mental aberrations. Their names are well

known today – Sigmund Freud and Carl Gustav Jung – but their ideas on creativity were not well received by their contemporaries. They only gained recognition in the 1950s after JP Guilford, the newly appointed president of the American Psychological Association, gave an acceptance speech with the simple title "Creativity". Guilford's cue was his amazement at the psychology of creativity not having gained more prominence in his field, and he even went so far as to refer to the lack of research into the cubbyholes of creativity as "appalling".

In the psychological community, Guilford's speech heralded a growing interest in creativity. At the same time it was a radical break with the way Freud's few inheritors, in particular, had described the link between mind and creativity. As Guilford saw it, creativity does not solely inhabit the borderland between madness and genius. It is quite common and is therefore found in unexceptional people too.

So creativity is not the preserve of geniuses like Mozart or van Gogh, nor does it unfold only in certain practices or spheres of activity such as music or literature. What is more, the result does not have to be an epic masterpiece or a groundbreaking invention. On the contrary, creativity is a basic ability in everyone. Some people just have it in greater measure than the rest of us and, for various reasons, express it more powerfully and in other ways.

A NORMAL WAY OF THINKING

Guilford distinguished between two kinds of thinking. One

was our ability to think "divergent" thoughts, broadening our mind, for instance by using association to find as many relevant solutions to a problem as possible – a sort of brainstorm to come up with lots of ideas in a very short time. The other kind was "convergent" thinking, mainly aimed at gathering our thoughts to find 'correct' or conventional solutions rather than 'odd' or creative ones – a pruning of ideas until we arrive at a few good ones or, preferably, the best.

According to Guilford, creative divergent thinking is observable everywhere, in everyone, meaning that being creative is quite normal. Pursuing these thoughts, Guilford's successors have begun working with different types of creativity: *exceptional* creativity and *ordinary* creativity. Some might call the former type 'Creativity with a capital C'.

Parts of the research community saw this as the end of creativity as something exceptional. Some even began to regard *all* types of thinking as manifestations of creativity: Could anyone even think a single thought without it?

When I speak or write, for instance, putting words together to create a meaningful sentence that aims to reach my listening or reading audience, there is an element of creativity at work. Sometimes very little, admittedly, but at other times quite a lot. Following the argument of this school, without some measure of creativity humans have no language at all.

Think of how far this removes us from the idea that madness and genius are intimately linked in uniquely

creative individuals like van Gogh. Creativity becomes something people share: We *have* it in common, and we *do* it together. Hence it is also something we begin to expect of each other.

CREATIVITY AT THE OFFICE

The award-winning television series *Mad Men* is set in the advertising business of the 1960s in New York City, its title referring to a contemporary nickname for those working in the many advertising agencies prominently located on Madison Avenue. The abbreviation 'Mad' is an obvious spoof on the wild and crazy ideas and behaviour often brought up when others discussed these advertising pioneers. And the characters in the series live up to its name. They are creative and also, at times, act quite irrationally.

A recurring issue is the status and position of the main character in the series, Don Draper, who works at a fictional advertising agency called Sterling Cooper. Should he retain his position as creative alpha male, or should he 'heel' and settle into a job, and a new social and creative persona, in a context where the hierarchies between creatives and non-creatives, old and young, male and female, overlord and underdog, are in flux?

His primary creative work process consists in lying on the sofa in his enormous office and allowing inspiration to flow to and through him, often aided by a shot glass he habitually replenishes with Canadian Club Straight or Old Fashioned, followed by a hard-earned power nap. As

Goethe said of Mozart, Don Draper is "altogether in the power of the demonic spirit of his genius".

Don Draper belongs to the first generation of creative advertisers to truly enjoy the same cultural status as artists. He is at the top of the hierarchy of 'creatives', whose job is simply to come up with concepts for campaigns, slogans and the like. Their rewards are admiration, recognition and bonuses, as well as expensive dinners, copious amounts of alcohol and, not least, women. All they have to do is produce and communicate ideas, which others then complete or convert into workable material. In *Mad Men*, creativity in its heroic form has become an integral part of the labour market.

Meanwhile, things are gradually changing at Sterling Cooper. A new generation of subordinate assistants is on the rise. Unlike the ultimate lone wolf, Don Draper, the new breed know how to be creative team players, despite fighting to earn credit for 'the good idea'. Much of their aggressive jockeying stems from the company's continued policy of mainly rewarding and motivating individual creativity, but new winds were blowing and new values were growing in the '60s, even when it came to creativity.

Mad Men deals with much more than a young generation rejecting their parents' and grandparents' social and financial values and privileges. The series also addresses the issue of who has the right to be creative, how and with whom, and it highlights the struggle to gain recognition for one's creative contributions, especially for those who are not white, middle-aged alpha males.

A STORY OF GROUP GENIUS

Don Draper is a dinosaur who, even in the historical context of *Mad Men*, looks increasingly like an endangered species. His heroic creativity certainly bears no resemblance to the creativities discussed by the American psychologist Keith Sawyer and other influential thinkers on modern organisation and leadership. They believe creativity is potentially relevant to all employees, not just a selected elite of 'creatives'.

Our managers and leaders can guide us towards creativity, or so we often hear. The British creativity and organisational scholar Chris Bilton believes there has been a shift from a "heroic" understanding of creativity to a "structural" understanding. In other words, there has been a change in the way we practise creativity and acknowledge it.

Bilton also describes this as the "social turn" of creativity. For one thing, we have come to see creativity more as an activity, something many people can relate to in their daily lives and work. In that sense, democratised creativity has become socially distributed among everyone, at least in principle. Another thing is that creativity has become social or shared. This is because we now primarily think of it as arising and taking place between and among people as they communicate and collaborate.

This thinking also changes the task of managing people at work. Bilton and others have studied how management attention is now being directed away from individual talent

and skills, and more towards social and organisational frameworks, processes and systems.

Writers of management books typically present their insights as novel, exciting and, inevitably, brimming with potential. We now see creativity in a new and better light. As Sawyer puts it: The truth about creativity is "always a story of group genius" – and it always has been, as the clarity of hindsight obliges us to admit.

Paradoxically, this means we can employ quite traditional, already existing management tools to foster creativity. We can change work procedures, structures and processes, redistribute resources such as time, materials and space, and assemble teams that pool different personalities and capabilities. It is not merely a matter of recruiting creatives, then 'hands-offing' so they can carry the load.

The many wide-open office landscapes in modern companies, which architects have laid out especially for creative businesses that work with design, advertising and communication, are a physical manifestation of this philosophy. Creativity arises between and among people in actual, physical spaces. This logic is also manifested in the huge popularity of the countless digital online platforms designed to enable creative co-creation. The only difference is that digital platforms allow companies to house their employees in virtual spaces, which are considerably cheaper to rent and to downscale.

MANAGEABLE CREATIVITY
Why do we suddenly have this new understanding of

creativity? What happened? Was Goethe really wrong? And have we now become wiser? Is creativity today fundamentally different from what Goethe observed in his world, some 200 years ago? Or should we be warier of this new type of creativity and the reasons behind its ubiquitous popularity?

The point, Bilton claims, is that today we perceive creativity as much more *manageable*. Managers can no longer simply recruit creative people to obtain more of this coveted personality trait. Instead, they are supposed to learn how to orchestrate creative processes among ordinary people doing relatively ordinary on-the-job tasks.

This is where I, for one, feel my inner sceptic begin to bristle: When creativity becomes 'manageable', meaning 'an issue to be handled by management', it makes managers even more relevant and significant – not to mention the experts writing the recipes for ideal management, who thereby create a more advantageous position for themselves. To put it bluntly, this just inflates the market for books that say "Yes, you too can manage your way to more creativity! All you have to do is this!" Inversely, it shrinks the market for research-based literature that says the opposite, namely that creativity is mysterious, capricious and impossible to distil in any concrete form – or, for that matter, for books like this one, which are sceptical of both arguments.

Perhaps what I should do is up the stakes on Bilton's point. Perhaps what he calls the "social turn" of creativity arises precisely from the wish to make creativity a specific

component that managers, applying a few simple tricks, can 'grow' to hitherto unseen heights? This could well be the eternal fountain of inspiration for less creative corporate consultants itching to write a new book.

The proliferation of theories about this sort of creativity may be due to the pronounced demand for such thinking – among buyers and readers of management literature, and also among those employing creativity scholars and approving their research grants.

Perhaps we are really just subscribing to the understanding of creativity we find most useful to us – or rather, most useful to *some* of us. You see, creativity also has a dark side, where not all is well and good – even in a world full of cool creatives.

AGAINST SOCIETY AND IN ITS SERVICE

CAUGHT IN THE MACHINE

A famous scene from Charlie Chaplin's classic silent movie *Modern Times* from 1936 shows his well-known protagonist, the Little Tramp, at work at a factory assembly line. His job is to tighten nuts on sheets of iron that whizz by, and he tries desperately to keep up.

The task seems as unreasonable as it is meaningless, and we have no clue as to the final product. At first the Tramp labours on while also trying to attend to some basic human needs – scratching his armpit, or swatting a fly – but the pace of the conveyor belt is so fast that he barely has time to tighten the nuts. This prompts him to leave his workstation and move along the assembly line, where, predictably and repeatedly, he bumps into other workers further down the line, throwing them off kilter too.

At a safe distance from the dirty factory floor, the image of a fleshy 'evil capitalist' in a suit and bow tie occasionally pops up on screens located in the strangest places. Seated behind a big mahogany desk, this transmitted figure scolds anyone taking too long a break. As punishment he orders

them all, again and again, to speed up their work on the assembly line.

The Tramp ends up at odds with his supervisors, the factory manager and even his hard-pressed co-workers. Finally he lands on the conveyor belt himself, desperate to keep up, and is literally eaten, chewed up and spit out by the machine. He ends up going mad – and getting fired.

Another key scene in *Modern Times* shows the Little Tramp in a new job, as a waiter at a club, performing an improvised pantomime song. The ambience here is completely different. Gone is the misery of living in a world controlled by heartless, greedy capitalists. He is finally happy, in tune with his work, with the people around him and with himself. Regrettably this state of bliss is brief, cut short by the realities of the outside world – the 'modern times' of the title, alluding to the years around the Great Depression. Chaplin nevertheless shows that despite the resulting hardship there are other ways to live than slaving away as a tiny cog in the industrial machine.

PUTTING POETRY INTO WORK

In the post-war era, and especially in the Western world, much popular culture and countless political debates have dealt with the organisation of our societies, workplaces and lives. Time and again, creativity pops up as 'the alternative' in films, literature, visual art, music, philosophy and the public discourse. It appears as a positive counter-ideal to plugging away at the assembly line, or to the humdrum

of daily routines steeped in the same old rigid economic rationality.

In this context, creativity represents everything that is hampered, even suffocated, by the crushing industrial and bureaucratic bulk of modern capitalism. It almost becomes synonymous with a better alternate existence to the one we have, in which we are alienated from our lives and our work. Whether standing at an assembly line or sitting in a tiny office cubicle, workers are represented as uniform beings with no independent identity and no opportunity to express their own creativity. Workers, caught up in meaningless forced routines and never truly themselves, are always alienated.

This was precisely the sort of Sisyphean toil Chaplin parodied in *Modern Times*. He once referred to the German philosopher Karl Marx, the quintessential socialist thinker, and claimed that humans had been reduced to mere "appendages of the machine" – the very role he gave his Little Tramp in the film's most iconic image, where he sits astride the massive inner workings of the factory.

The opposite of joyless, alienated, repetitive working and living is creativity. Although post-war figures like the American historian Theodore Roszak and the German-born critical theorists Herbert Marcuse and Erich Fromm certainly did see creativity as a productive activity, much like remunerated work, they did not see it as an *unfree* activity. On the contrary, they saw free, deliberately creative activity as an essential part of being human, setting us apart

from other species: creativity as part and parcel of the free human spirit.

Even so, according to Marcuse and his like-minded peers, due to the demands of modern life, being creative is not something people can simply throw themselves into. But what we can do is struggle or sneak our way towards exercising creativity, fitting it into the cracks and crannies of daily lives that are otherwise jam-packed with economic rationality. Alternatively, we can fight politically for the right to integrate creativity into our daily work. As the Greek-French philosopher Cornelius Castoriadis put it, referencing the fact that etymologically 'poetry' means 'creation', it is all about "putting poetry into work".

These ideas are actually inspired by Marx's *Paris Manuscripts*, which are thoughts on economics and philosophy that he committed to paper in 1844 but never published. These notes first appeared in English after World War II, and Marx never used the German equivalents of the words 'creativity' or 'creative'. Linking work and creativity was an idea that gained ground during the 1960s, thanks to the philosophers and strong political voices of the countercultural movements of the time.

In his manuscripts Marx did, however, compare the free, productive activities workers would be able to cultivate – after the downfall of capitalism – with a composer writing music, or an architect designing buildings, so linking Marx with creativity was not too far a stretch.

Regardless of who used what terminology, or whether it was entirely in line with Marx's own thoughts, this idea

marked a decisive development in our modern view of creativity. Suddenly, it was part of the very essence of being human, and there was a problematic gap between creativity and the existing society. That is also why many social critics of that age lamented that we humans had created an inhuman society, which kept us from being creative and thereby becoming whole individuals. The most significant definable factor in this deplorable situation was the way we worked.

THE PERENNIAL GALE OF CREATIVE DESTRUCTION

Much of this has changed, at least in large parts of the Western world. In a country like Denmark creativity is now hailed as a cornerstone of the national economy and a desired attribute of companies and employees. Creativity no longer stands out as the diametrical opposite to work, financial prudence and capitalism. Rather, it has become their ideal form, based on the reasoning that if we can organise work as new management theories recommend, we will bring more creativity into our lives, not less.

We still regard creativity as synonymous with freedom, but today we do this much more by linking it with ideas of economic growth, technological development and, not least, the necessity of change. This brings us back to innovation. Companies and individuals, even humanity itself, must change, re-invent and re-create themselves and the world. To achieve this, creativity is a must.

As an example, let us consider the general thinking

behind the way Denmark, Europe and most countries in the West have organised their economic systems. Until 1980 or so, Western economics was dominated by the Scottish economist Adam Smith's idea, originating in the 1770s, that the free market always seeks balance or 'economic equilibrium'.

This has now been replaced by an idea presented by the Austrian-American economist Joseph Alois Schumpeter: "the perennial gale of creative destruction". Now fashionable more than half a century after he proposed it, Schumpeter's theory suggests we should actually strive for economic imbalance. According to corporate leaders and financial experts across the globe today, disequilibrium creates activity and dynamics in the economy, generating innovation and growth.

Schumpeter's expression reveals that in this respect creativity is a key ally that breaks down old structures and thinking, triggering crises and breaking ground for new things to grow. New ideas, products or business models mean that old ones, no longer viable, will waste away and die. Just think of certain high-profile, widely publicised debates in recent years: Uber versus conventional taxis, or Airbnb versus hotels and hospitality chains. New digital business models seem poised to drive old occupations, solid companies and firmly established labour market mechanisms to extinction.

On a personal level, too, we experience creative destruction almost daily. Each update to an operating system on one of our digital devices does more than

correct software errors or improve performance. Because new software always calls for more computing power, updates gradually make our hard-working hardware obsolete. With devices under pressure to process ever larger volumes of data, we are forced to upgrade to new tablets, mobiles or computers if we want to keep up.

So in Schumpeter's view, creativity is what brings change and growth – through destruction and obsolescence. The latest buzzword for this is 'disruption'. It is worth noting that the basic notion is one Schumpeter inherited from the German sociologist Werner Sombart, who in the early 1900s studied the economic effects of humanity's most destructive behaviour: warfare. Sombart found that the main driver of progress, in terms of socio-economic development, was the new technologies and the manufacturing and technological innovations that surfaced in the wake of the wartime production apparatus.

THE ULTIMATE MONOPOLY MAN

Adam Smith thought of us all as merchants. In Schumpeter's universe we drive the economy by inventing, creating and manufacturing new products and ideas. That is why the theory of creative destruction is ideally suited to the notion of a new economy based on creativity, ideas, knowledge and inventions.

However, the logic of Schumpeter's economics cannot make do with any old kind of creativity. It demands a brand of creativity that most of all resembles Augustine's religious idea of the Creator: a heroic entrepreneur who

suddenly introduces a fully fledged business idea or product that throws the existing market into disarray, thereby producing a gale of creative destruction. Importantly, this product should preferably be related to intangible intellectual property rights: patents, copyrights or registered trademarks.

That may be precisely why we are so awed by people like Steve Jobs, even though he did not personally play any major role in developing the Apple technologies we know today. What is more, many key elements in Apple's product design and functionalities were not invented by the company at all but resulted from large, collective and mainly publicly financed research projects to which Apple either purchased access or looked for 'inspiration'.

Jobs was, more than anything, an extremely talented business strategist. I would even go so far as to call him the ultimate monopoly capitalist, based on what he gave the world: the 'freedom' to buy entertainment and information from a single location – the Apple App Store.

We nonetheless salute him as a creative pioneer of high-tech emancipation. We do so because we have become used to thinking about the relationship between creativity and the history of technology as a process driven by the ingenious ideas of heroic individuals. According to the British historian of technology David Edgerton, we are incredibly fixated on innovation and we love telling stories of new technologies as though each one was invented at a specific time, in a certain place, by a particular individual. The Macintosh computer: 1984; California; Steve Jobs.

THE END OF HARD WORK AS WE KNOW IT?

Before he died in 1931, the American inventor and businessman Thomas Edison and his numerous assistants had taken out no fewer than 2,332 patents for technologies that included the phonograph and the electric light bulb. As far as 'genius' was concerned, Edison once purportedly described it as "1% inspiration and 99% perspiration". These words bring the awe-struck, starry-eyed, heroic conception of creativity down to earth, dismantling the idea that creativity comes to people as a revelation. Creativity, Edison argues, largely consists of blood, sweat and tears – or at least of very hard work.

At the other end of the scale, a Danish-authored report entitled *Creative Man*, published by the Copenhagen Institute for Future Studies in 2006, posited that in the future our work will consist of "99% inspiration and 1% perspiration". Almost exactly a century after the words famously attributed to Edison, the Danish authors of the report believe that the jobs people will do for a living in the future will not be heavy manual labour, like Chaplin's poor Tramp on the assembly line. They will be more in the style of free, playful, creative mental work, akin to the artistic process. People will work creatively.

In my view, the Institute has misinterpreted Edison's thinking, since what he referred to as 'hard work' was precisely the sort of creative mental effort necessary to obtain results. Whether the Danish report misappropriated Edison's words or not, the core message in their diagnosis of humankind's working future is clear: Work

is moving into a phase where creativity is the principal factor of production. And according to the Institute, this development points toward workplaces and careers that will enable us to find self-actualisation and self-realisation in and through our work. The report's authors avow that the jobs of the future will fulfil our need to live out the creativity that makes us human.

PRIVILEGE OR PREREQUISITE?

All this freedom comes at a price, however. More and more, creativity is something that is expected of us. It is almost an imperative, a duty impressed upon us on the job or in the classroom. We also expect creativity of ourselves, since nowadays it is a central aspect of our personalities, our capabilities and our potential to grow and improve. Perhaps that is why creativity is something we are willing, often even eager, to embrace. Just ask yourself this: Who would *not* want to be creative? Who, at an individual level, would *not* want to be the most creative and inventive person they could potentially be?

The German sociologist Andreas Reckwitz begins his 2017 book *The Invention of Creativity* by observing that people are all but incapable of formulating a desire to not be creative. Some of us may admit that we are not able to be creative, but that is a problem we can solve by training patiently and spending quality time with a few self-help and how-to books. Nowadays, imagining someone wishing they were *not* creative is almost as absurd as imagining someone who wants to be evil.

Amidst our enthusiasm for the sweet promises of creativity, even in our work lives, we must bear in mind that creativity's triumph also, once again, brings up an assortment of very concrete problems.

Somewhat paradoxically, they are remarkably reminiscent of the worker alienation and the capitalist exploitation lamented by critical voices of the 1960s counterculture – the very ills these critics believed creativity could resolve. As a matter of fact, today we see a 'creative precariat' working under particularly unstable and problematic labour conditions in design and fashion, art and culture, film and media – sectors often emphasised as the breeding grounds of the liberated, creative workers and jobs of the future.

This coincides with a general shift in what we expect of our workplaces and our work. Far into the twentieth century, work was primarily perceived as an activity we had to get done, enabling us to live our real lives in the time that remained. This thinking gave birth to a popular slogan used during decades of union clashes and campaigns: "Eight hours' labour, eight hours' recreation, eight hours' rest."

Today's thinking is somewhat different. Many of us harbour non-negotiable expectations: a high level of job satisfaction, and perhaps even feelings of joy, enthusiasm or dedication in our work, doing jobs that enable us to realise our full potential as whole and, if possible, creative human beings.

For many people, the chance to make a living from their creativity is a dream they are willing to invest in quite

heavily. That may be why the creative sectors and industries are especially hard pressed by what many social scientists call 'hope labour', which is often performed with no formal monetary compensation or contractual agreement. Such work is typically temporary, uncertain or precarious, taking the form of project-based employment, or non-remunerated training or internships. Even so, young people are especially prone to accept unfavourable conditions as an investment in their dreams of someday achieving self-realisation through their work. Their hope: to combine personal interests and obligations; business and pleasure; creativity and work. In short, they wish to *be* creatives.

BACK WHERE WE STARTED

In my favourite scene from the 1979 Monty Python film *Life of Brian*, the leading character stands at a tall window-opening in his family home overlooking a courtyard, obliged to address a throng of uniformly tunic-clad devotees who have miraculously crowded into the narrow space cluttered with drying laundry, woven baskets and a labyrinthine confusion of stairways and balconies. The entire scene is composed in shades of tan, beige and off-white.

Throughout the film, Brian is mistaken for the Messiah – having been born on the same night as Jesus, on the same street in Bethlehem – but he has no wish to be worshipped. Instead, the reluctant prophet tries to convince the multitude that they do not *need* to follow him or

anybody else. "You've got to think for yourselves. You're all individuals!"

But his oratorical efforts are in vain. The crowd responds, in unison, "Yes, we're all individuals!" Ironically, one old man – who stands out from the crowd by insisting he is *not* different – is promptly and collectively shushed. So much for independent thinking. Instead, the crowd calls out as one, entreating Brian – "Tell us more!" – to teach them how to become more independent.

Brian's instruction to the crowd, telling them to each work things out for themselves, reminds me of the way we talk about creativity today. We have made it a general imperative. An activity we must perform, and also a way of being in the world. A dictum not unlike the one handed down by the church father Augustine.

However, unlike Augustine, who regarded every kind of human creativity as sacrilege, the dictum today is: "Be creative and multiply …" In essence, this calls upon us all to be unique. Each of us must be distinctive. Each of us must be able to re-create and renew our persona and our surroundings. No one ought to simply know or accept their place in the world. This requirement puts us all under enormous pressure, because the entire idea of creativity in our daily lives and jobs is closely linked to the stressfulness and performance anxiety that also are a prominent part of our culture – not least because we have internalised this requirement to be creative as our own personal aspiration. Nevertheless, no matter how willingly or eagerly we seek to

be creative, in this guise creativity has very little to do with the playful freedom with which it is so readily associated.

My favourite scene from *Life of Brian* reveals an even more fundamental philosophical paradox, too: How can we *all* be unique and creative at the same time? If we are, then who among us is special? And how far have we come? More or less full circle, which brings my reflections in this book back to the longtail boat in the Andaman Sea – an exquisite, isolated natural paradise whose locals are suddenly supposed to start cultivating their creativity and jostle their way to the front of the global peloton, pedalling like madmen – just like the rest of us who want to be, and invariably have to be, oh so creative.